ROSE ART MUSEUM

Brandeis University

DOR GUEZ

100 STEPS TO THE MEDITERRANEAN

GANNIT ANKORI AND DABNEY HAILEY

With essays by Dor Guez and Samir Srouji

Published on the occasion of the exhibition
Dor Guez: 100 Steps to the Mediterranean
Curated by Gannit Ankori and Dabney Hailey
Rose Art Museum, Brandeis University
September 20–December 9, 2012

Dor Guez: 100 Steps to the Mediterranean is supported by Artis -
Contemporary Israeli Art Fund; Schusterman Center for Israel Studies,
Brandeis University; The Ruth Ann and Nathan Perlmutter Artist in
Residency Annual Award Program; Lois Foster Exhibition Fund; and
Office of the Provost, Brandeis University.

Rose Art Museum Staff.
Roy Dawes, Director of Operations
Dabney Hailey, Director of Academic Programs
Cara Kuball, Exhibitions Manager
Kristin Parker, Collections Manager
Nicole Rosenberg, Office Manager
Penelope Taylor, Curatorial Assistant

Editors: Gannit Ankori and Dabney Hailey
Hebrew translations by Daria Kassovsky and Gannit Ankori
Copy Editor: Julie Hagen
Graphic Design: Wilcox Design
Printed by Kirkwood Printing

Picture credits:
©Dor Guez; Dvir Gallery, Tel Aviv and Carlier Gebauer Gallery, Berlin

Front cover: *Samira, Lod Ghetto, a year after 1948,* from the series,
Scanograms #1, 2010, manipulated readymade, archival inkjet print,
23 ½ x 29 ½ inches

Distributed by University Press of New England ISBN 978-0-615-64487-5

Rose Art Museum
Brandeis University
MS 069
415 South Street
Waltham, MA 02453-2728

t. 781-736-3434 f. 781-736-3439
www.brandeis.edu/rose

CONTENTS

PLATES

ACKNOWLEDGMENTS

Many individuals have been critical to the realization of Dor Guez's first major museum exhibition and catalogue in the United States. First and foremost we thank the artist, whose challenging, multifaceted and beautiful work is mirrored in his person. His generosity, openness and sharp intellect have positively impacted us every step of the way. Rose staff members are unmatched in their excellence and collegiality. We are deeply grateful to Director of Operations Roy Dawes, Collection Manager Kristin Parker, Office Manager Nicole Rosenberg, Curatorial Assistant Penelope Taylor and Exhibitions Manager Cara Kuball and her amazing crew. The museum would not function without Brandeis students, whose intelligence and enthusiasm are vital components of everyday life here. We thank them all. Meryl Feinstein '12, Sara Chun '12, Nera Lerner '12, Sara Weininger '13, Nicole Bortnik '13, and Lenny Schnier '13 were particularly helpful. We also thank the artist's galleries, Dvir Gallery in Tel Aviv and Carlier Gebauer in Berlin, for their logistical support.

Guez views the conversations that emerge from his art as an integral element of the work itself. Likewise, we consider fostering dialogue and reflection essential components of our curatorial work. Many people helped us develop this catalogue and the exhibition programs with these aims in mind. The artist wrote a moving essay. Artist and architect Samir Srouji contributed a riveting analysis of Guez's installation and videos. Jean Wilcox's stunning book design beautifully conceptualizes themes in the work. Cynthia Cohen, Leigh Swigart and Naoe Suzuki in the International Center for Ethics, Justice and Public Life at Brandeis collaborated with us on substantive programs, from peacebuilding workshops to panel discussions. Myriad faculty and students from across disciplines—Fine Arts, Sociology, Theater, Legal Studies, Anthropology, Film Studies, Psychology, Near Eastern and Judaic Studies, Biology, History and Politics, among others—will expand the discussion by holding classes and extracurricular events in the gallery, enlivening debate throughout the run of the show.

Guez first visited Brandeis in June 2011 when he participated in the panel "Multicultural Israel and the Visual Arts" sponsored by the Schusterman Center for Israel Studies. His visit sparked the idea for this exhibition. We are grateful to the Schusterman Center, especially Director Ilan Troen and former Assistant Director Rachel Litcofsky, for their intellectual and financial support of this project.

This exhibition comes at an exciting moment of rebirth for the Rose in the aftermath of great controversy about the status and role of the museum within the university. It is an honor and a privilege to reignite the Rose's historically significant tradition of showing contemporary artists on the cusp of international recognition with *Dor Guez: 100 Steps to the Mediterranean*. We hope to demonstrate the intricate relationship between aesthetic experiences and the development of critical thinking—an essential component of a good liberal arts education—and how contemporary art can enable engagement with diverse cultural perspectives and the pursuit of social justice, pillars of this university's mission.

Guez's presence on campus would not be possible without the Ruth Ann and Nathan Perlmutter Artist in Residency Annual Award Program, which has previously brought cutting edge artists such as Dana Schutz, Barry McGee and Fred Tomaselli to campus. We are also grateful for the support of Artis–Contemporary Israeli Art Fund. We welcome and thank Chris Bedford, the Rose's newly appointed director, who has generously embraced this project and offered pivotal guidance during its final stages. We thank President Frederick Lawrence and Provost Steve Goldstein, whose demonstrated, inspired commitment to the museum reaffirms and deepens the relevance of the Rose within Brandeis University. Finally, we greatly appreciate the loving support and patience of our families.

Gannit Ankori and Dabney Hailey

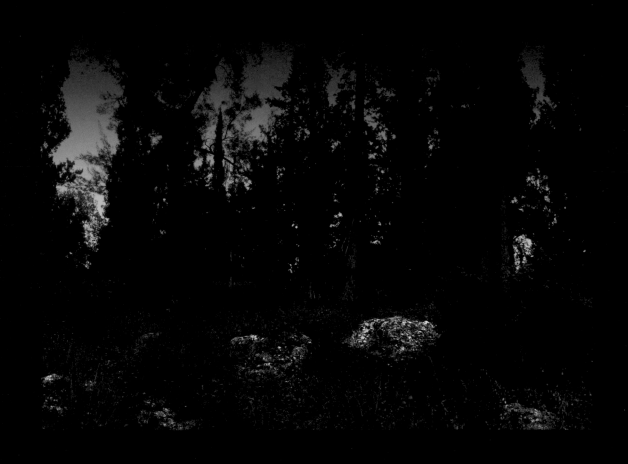

Veiled by darkness and overgrown with wild vegetation, these nocturnal landscapes both reveal and obscure remnants of Palestinian architecture destroyed or fallen to ruin in the city of Lod (formerly al-Lydd) after 1948. On July 13, 1948, Israeli military forces conquered the city and evicted the vast majority of the population. Using only light from the surrounding city, Guez photographed these architectural fragments at night, evoking the visual trope of the Romantic ruin.

Lydd Ruins
2009
chromogenic prints
each 47 ¼ × 59 inches

Opposite:
Lydd Ruins (The Forest) 1

Above:
Lydd Ruins 2

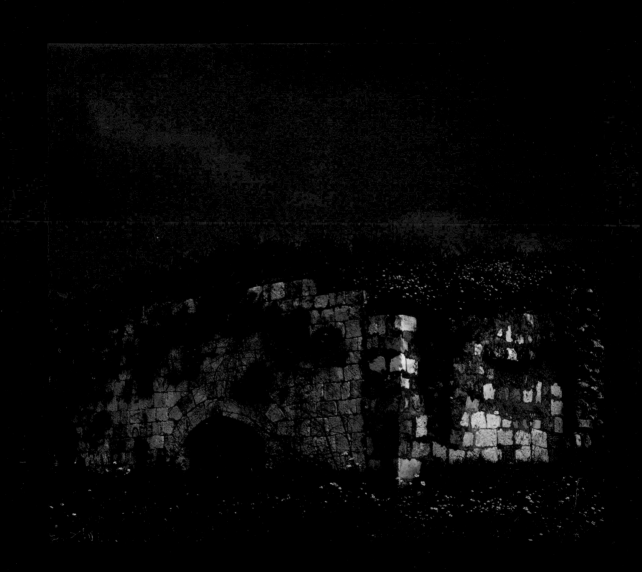

Lydd Ruins 3

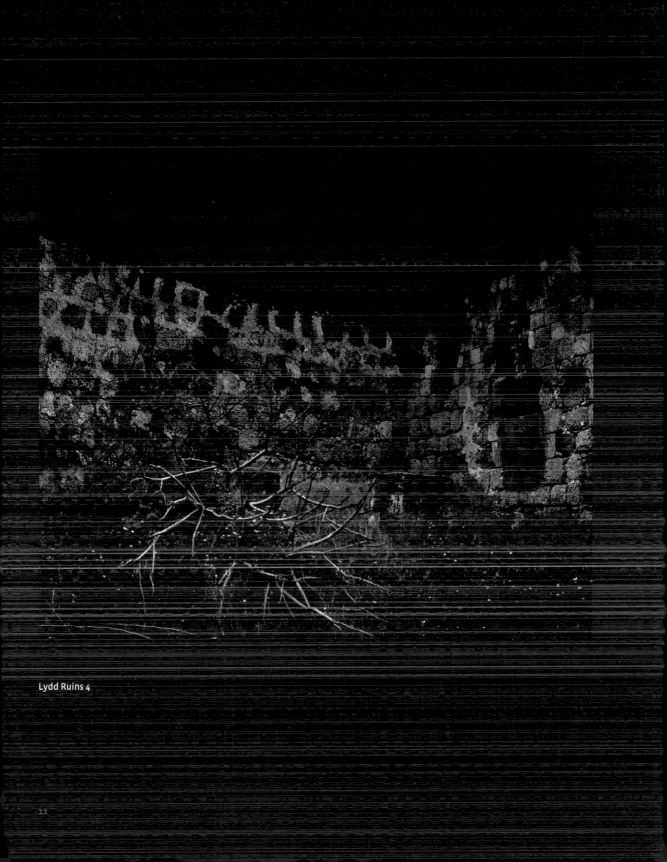

Lydd Ruins 4

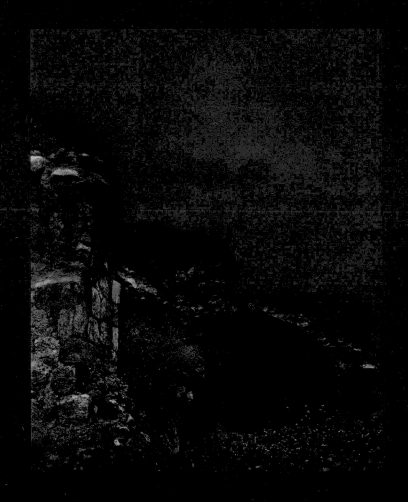

Lydd Ruins 6

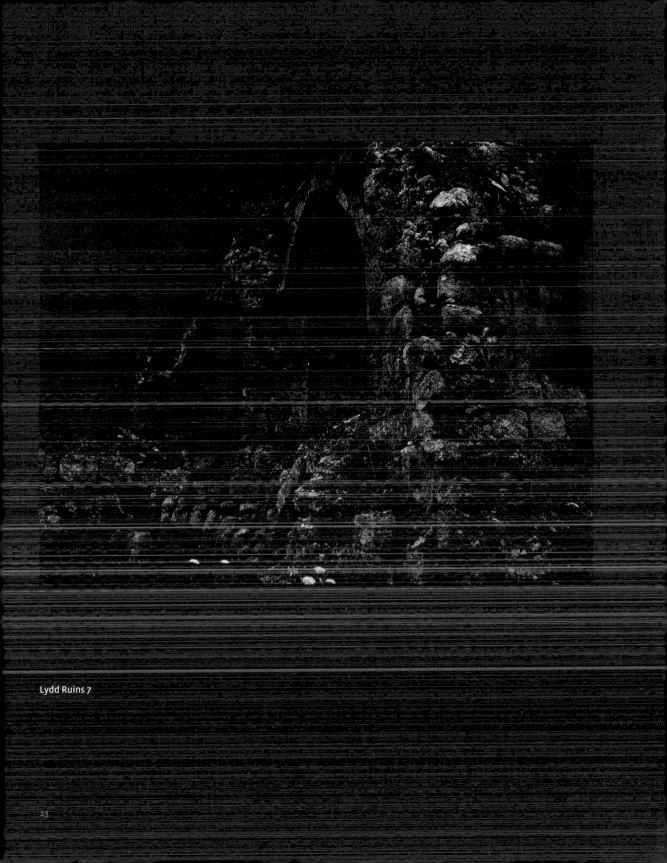

Lydd Ruins 7

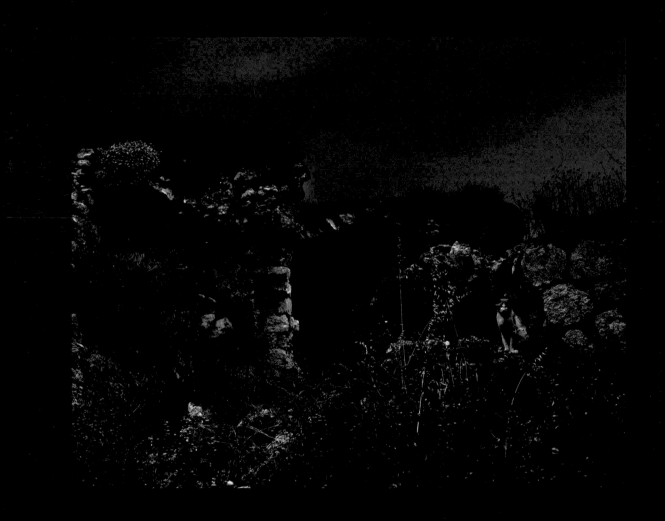

Lydd Ruins
(The Night Watch) 8

Lydd Ruins
(Market Square) 10

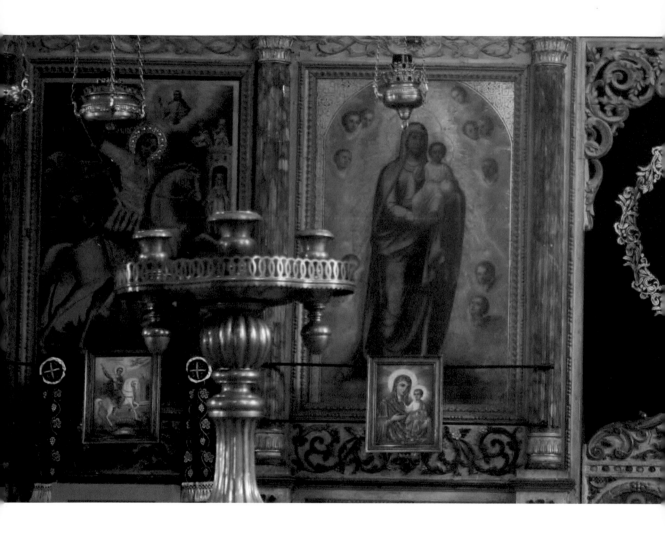

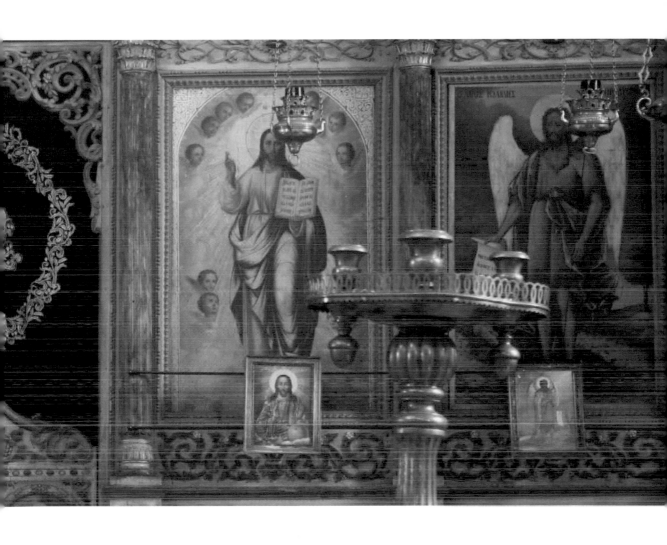

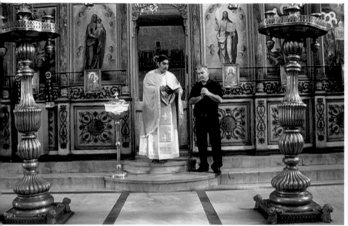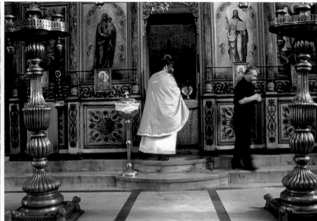

Previous spread and above:
Untitled (St. George Church)
2009
two-channel video installation
6:59 minutes

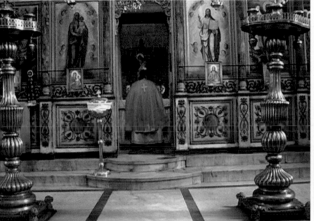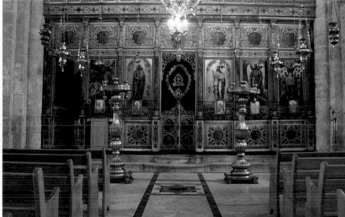

The Greek Orthodox Church of St. George in Lod was built in Ottoman times on the site of an earlier basilica housing the tomb of its martyred namesake. For centuries the church has served as the heart of the Christian community of this ancient city, formerly known by its Byzantine name, Georgiopolis, and its Arabic name, al-Lydd. *Untitled (St. George Church)* is a two-channel video installation comprised of a large video screen suspended in midair, showing the church's iconostasis (an icon-covered wall that separates nave from altar), and a second small-screen video showing a priest giving a sermon in Greek, a language that is not understood by the parishioners, while an interpreter translates his words into Arabic. Guez punctuates each act of translation by adding the sounds of an oud, a string instrument associated with traditional Arab music not played in church, making audible the cultural gap between the church leaders and the congregation.

SABIR (TO KNOW) Gannit Ankori and Dabney Hailey

Dor Guez's exhibition *100 Steps to the Mediterranean* generates overlapping geographical, temporal, and epistemological journeys. Employing an array of video and photographic practices, the artist leads us into three distinct sites in contemporary Israel—the town of Lod, Ben Shemen Forest, and the Mediterranean shore in Jaffa. He also gives us access to the homes of three generations of one family, the Monayers, whose lives and identities are intertwined with these places.

The installation invites us to roam in a basilica-like space; to sit down in domestically scaled enclosures; to peer closely at archival material; and to imagine ourselves in expansive outdoor sites, on the beach or in a forest. The scale of the photographs and projections within these varied environments ranges from intimate to monumental, the lighting from meditative to cinematic. The soundtracks are multilingual, transitioning back and forth between Hebrew and Arabic, with Greek and English interjections. These shifting modes of presentation, perception, and engagement—reinforced by the indexical qualities of photography and video—promote disparate ways of seeing that in turn instigate diverse ways of knowing.

The exhibition opens with a large, luminous projection of the iconostasis of St. George Church in Lod.[1] Suspended in midair in a dimly lit gallery, it is accompanied by a smaller video playing liturgical recitations in Greek and Arabic, punctuated by the stilted notes of an oud. A series of nine nocturnal photographs of fragmented architectural ruins, overgrown with wildflowers and lush vegetation, surrounds the iconostasis. These monumental images initially appear otherworldly, Romantic and sublime. Yet the titles and dates of the works—*Untitled (St. George Church)* and *Lydd Ruins*, both from 2009—situate the images firmly in present-day Lod, a town in central Israel eleven miles southeast of Tel Aviv. Guez's artistic reconstruction of Lod, however, looks nothing like the contemporary town, a neglected and disregarded place rife with drug trafficking, social unrest, and poverty. At first sight, the evocative imagery and dramatic ambience seem to point to Lod's layered history, which spans three millennia and includes the Greek, Roman, Byzantine, Arab, Crusader, Ottoman, and British eras. The church

suggests a glorious Christian heritage in the Holy Land, while the ruins are reminiscent of ancient archeological sites.

Instead, these images address the recent past: the violent history of al-Lydd/Lod during the 1948 war—Israel's War of Independence, called the Nakba by Palestinians (*nakba* means "catastrophe" in Arabic). In mid-July 1948, the Israeli military engaged in fierce fighting, commanded by its famed military (and later political) leaders Yigal Allon, Moshe Dayan, and Yitzhak Rabin, to conquer the Palestinian town of al-Lydd, which was defended by local Palestinian fighters as well as the Arab Legion. Israeli narratives claim the conquest of al-Lydd as a decisive battle, given the town's airport and its strategic location connecting the coast to Jerusalem.[2] Palestinian narratives emphasize the events that followed. On July 13, 1948, virtually the entire civilian population of al-Lydd and its environs—tens of thousands of people—were forced to leave the city on foot; some perished. Their homes, land, and property were either stolen by looters or confiscated by the newly established State of Israel.[3] After the war al-Lydd was renamed Lod, and the town was resettled by Jewish inhabitants, mostly new immigrants.[4]

A virtually unknown chapter of the city's history—written out of both Israeli and Palestinian nation-building metanarratives—relates to the approximately one thousand inhabitants who stayed in al-Lydd. These people, mostly Christians, took refuge in the Church of St. George. After the war, the church and the surrounding area were fenced in, placed under military rule, and dubbed the "Lod Ghetto." Over time, the people there were allowed to resettle outside the ghetto and were given Israeli citizenship.[5]

In her biography of Yigal Allon, the prominent Israeli historian Anita Shapira chronicles both the battle of Lod and its aftermath. She describes the "sight of an entire town going into exile" as a "heart-breaking scene" that evoked "pangs of conscience" in the Israeli soldiers who witnessed and perpetrated the forced eviction. She then insightfully explains the mechanism by which the young nation justified this tragedy as a brutal but unavoidable part of the

war: "Transposing the tragedy from the personal to the national plane and from the private to the historical lent the events a more remote dimension released from the strictures of ordinary morality."[6] Through his art, Guez reverses the process of depersonalization and distancing that Shapira describes. He insists on reintroducing individual experiences and personal testimonies from al-Lydd/Lod into our range of vision, exposing the tragic human dimension that had been repressed and hidden from view.

One family's personal testimonies are recorded in a series of videos that form the linchpin of the exhibition. Screened in four intimate chambers located at the heart of the installation, the videos focus on three generations of a Christian Arab family from Lod. They are Jacob and Samira Monayer, the artist's grandparents; two of their sons, Sami and Samih; and their granddaughter, Samira, named after her grandmother. As we sit face to face with them in their living rooms (and even gain access to a kitchen and bedroom), we learn about their lives, experiences, and subtle family dynamics. The camera's mostly static stance, eye-level height, and physical proximity to the protagonists creates an intimate, empathetic ambience. The fact that we occupy the artist's position transfers the Monayers' trust in him to us. Guez provides a platform for his relatives' voices, and the edited results are both testaments to and poetic meditations on family, generational shifts, and multiple modes of belonging.[7]

Many of the videos begin with a family member self-identifying by name and place, but as they proceed to speak, their assignations of identity become increasingly intricate. *July 13* opens with Jacob Monayer proclaiming in Arabic: "My name is Jacob, son of Salim Yusuf Rizek Monayer of Lydd. I was born in Lydd in 1920," followed by a Hebrew variation: "I was born in 1920 in Lod. My father is Salim, my mother is Huda Ibrahim Shbeta." His profound identification with his hometown is bracketed by birth and death, hence the video ends with his forceful declaration: "My father ... is buried here, and my father's father, also buried here, and my great-grandfather is also here ... in Lod Cemetery. I want to be buried in the cemetery where my father is."[8]

These traditional articulations of belonging—based on allegiance to a family tree rooted in a specific place, from generation to generation—frame his testimony. Throughout the thirteen-minute piece, however, interlacing tales of displacements and ruptures abound. Jacob describes the events of 1948, recalling the hardships—the battle, seeking refuge in St. George Church, his family's restriction to the ghetto, and the loss of their possessions. In time the Monayers became citizens of the newly established state and rebuilt their lives.

While Jacob transmits this painful legacy, the video interweaves two other temporally disparate actions. Both relate to the family's Christian identity. Guez and Jacob go to St. George Church, repeatedly finding the doors locked, and Jacob points out the location of his ghetto housing. They finally appear in the nave of the church, where Guez takes his grandfather's picture, documenting Jacob's lineage and pride in this place, even as he expresses his cultural distance from the Greek patriarchy. Meanwhile, Guez decorates his grandparents' Christmas tree, a fake evergreen, with lights and ornaments. This activity spans the video, which ends when the tree is fully embellished. In the final section, describing his children and grandchildren who grew up in Lod, not al-Lydd, Jacob says, "Look, at the moment they are more Israeli." Off camera, his wife, Samira, adds, "They are Arabs who live in Israel," and Jacob agrees. Guez is heard off camera asking, "Is it that simple?" and his grandfather replies with conviction, "Yes, that's enough."

Whether it is indeed enough is played out in the rest of the videos, which feature the second and third generations of the family, who continue to dwell on questions of place, language, and identity. In *Watermelons under the Bed*, Samih describes his father's situation after 1948 and his decisions as a Christian Arab in the newly established State of Israel: "He grew with it, and if he wanted to survive, he had to adjust to the new situation, dance between the drops and survive in the new environment." The camera cuts back and forth between Samih, sitting on his parents' couch, and Jacob, who is shown only in fragments, at home: lying in bed, examining watermelons, and sitting in the kitchen cutting sabra cacti. These plants symbolize attachment to the land for both Palestinians and

In this video, the artist's grandfather Jacob Monayer (1920–2011) recalls the watershed events of July 13, 1948, when his hometown, al-Lydd, was conquered by Israeli military forces. Most of the town's population was forced into exile. Jacob was among about one thousand Palestinians, most of them Christian, who sought refuge in the Church of St. George. After the war, they were not permitted to return to their homes, which were looted, and were resettled in a fenced-in area around the church dubbed the Lod Ghetto. Jacob and his family eventually became citizens of the newly established State of Israel.

July 13 1
2009
video
13:18 minutes

Jacob's son Sami Monayer (b. 1956) articulates the complexity of his range of possible identities (Arab/Christian/Israeli/Palestinian) situated between what he describes as "Eastern" and "Western" cultures. While he attempts to express his position, his wife and daughters (heard off-camera) interrupt him, arguing with his self-definitions. Sami traces the oscillations between his sense of belonging to and alienation from both Israelis and Palestinians as a member of the Christian minority within the Muslim minority, within the Jewish majority of Israel. The title of the video links two distinct types of cars popularly associated in contemporary Israel with Arabs (Subaru) and Israelis (Mercedes).

Subaru-Mercedes 2
2009
video
6:00 minutes

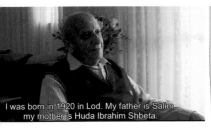
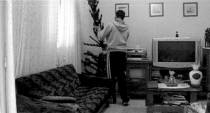
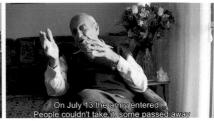

I was born in 1920 in Lod. My father is Salim, my mother is Huda Ibrahim Shbeta.

On July 13 the army entered... - People couldn't take it, some passed away

1

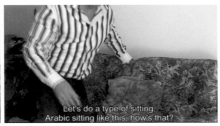

Let's do a type of sitting, Arabic sitting like this, how's that?

2

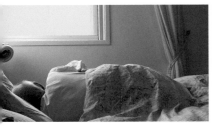

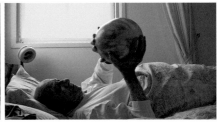

3

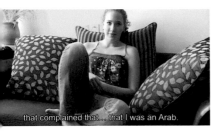
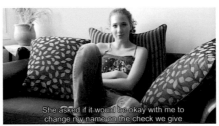
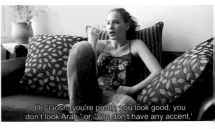

that complained that... that I was an Arab.

She asked if it would be okay with me to change my name on the check we give

Or, 'Gosh, you're pretty, you look good, you don't look Arab,' or, 'You don't have any accent,'

4

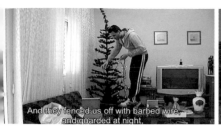

And they fenced us off with barbed wire, and guarded at night.

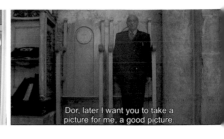

They still have the keys in Ramallah... Here's the key to my house.

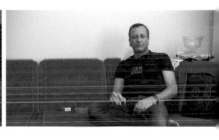

Dor, later I want you to take a picture for me, a good picture.

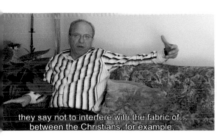

they say not to interfere with the fabric of, between the Christians, for example,

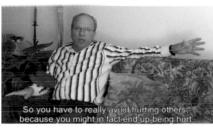

So you have to really avoid hurting others, because you might in fact end up being hurt.

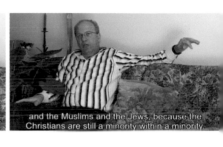

and the Muslims and the Jews, because the Christians are still a minority within a minority.

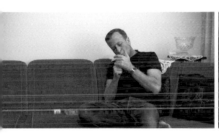

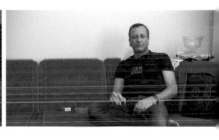

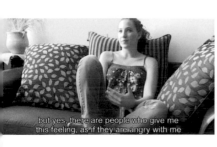

but yes, there are people who give me this feeling, as if they are angry with me

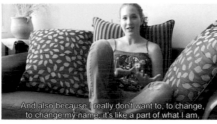

And also because I really don't want to, to change, to change my name, it's like a part of what I am,

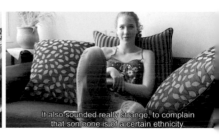

It also sounded really strange, to complain that someone is of a certain ethnicity.

This selection of videos focuses on three generations of the Monayer family, whose personal memories and everyday experiences intersect with historical milestones, ranging from the dramatic events of 1948 through Israel's nation-building years and into the present.

3 **Watermelons**
 under the Bed
 2010
 video
 8:00 minutes

Guez's camera dwells on Jacob Monayer in intimate settings with watermelons and sabra cacti. Intermingled with these quotidian moments, Jacob's son, Samih, recalls his parents' process of adjusting to life in Israel after 1948 and the choices they made for their children. The watermelon and the sabra cactus carry symbolic significance linking identity and place within both Palestinian and Israeli cultures.

4 **(Sa)Mira**
 2009
 video
 13:40 minutes

Samira is a first-year psychology student at the Hebrew University of Jerusalem. Her colloquial Hebrew, sartorial choices and mannerisms render her indistinguishable from her Jewish Israeli contemporaries. Guez asks her to recount a recent experience: in the restaurant where she works as a waitress, her Arabic first name evoked racist responses, causing her boss to ask her to change her name to the more Jewish-sounding Sima; they finally settle on Mira. As she recalls the incident and repeats it at Guez's prodding, she begins to articulate the complexity of her identity and how racism impacts her life.

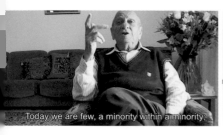

Today we are few, a minority within a minority,

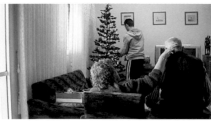

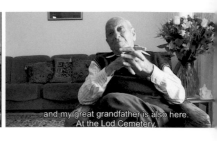

and my great grandfather is also here.
At the Lod Cemetery.

and when they want to slightly detach me from
my innate Arabness, then I am no longer an Arab.

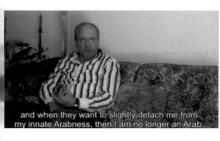

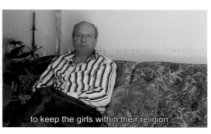

to keep the girls within their religion,

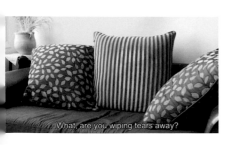

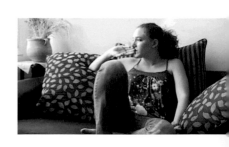

What, are you wiping tears away?

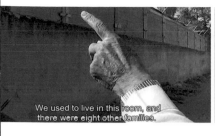

We used to live in this room, and there were eight other families.

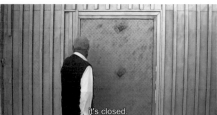

it's closed.

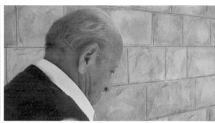

Come on, I don't.
It's not, it's not fair to do this to me...

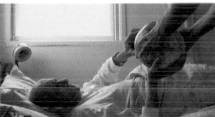

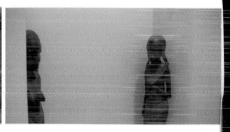

or something of that sort, and it is here that the ambivalence is created,

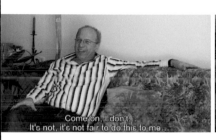

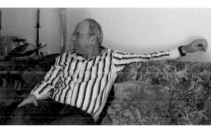

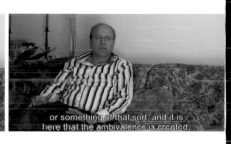

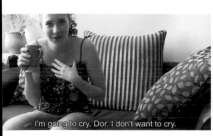

I'm going to cry, Dor. I don't want to cry.

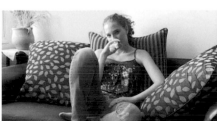

Israelis.[9] Jacob and his family, as Christian Arab citizens in Lod, are both. Looking at a watermelon Guez brings him, Jacob insists, "I don't know [if it's a good one] ... I used to know but not anymore, everything changed. I used to grab a watermelon and know." Once he holds it, however, he decisively knows, but his momentary doubt becomes a symbol for his community's displacement within its own land. Growing up, Samih explains, "We lived in a vacuum."

Another of Jacob's sons, Sami, the focus of *Subaru-Mercedes*, reinforces the delicacy of labels within his sociopolitical matrix.[10] After noting his allegiance to Lod and his extensive "knowledge of the land [of Israel]," he defines himself as a Hebrew-speaking Israeli citizen, a Christian, an Arab, and a Palestinian.[11] He describes his culture as "Western" with some "Eastern" elements. As he attempts to convey this complex position, his wife and daughters are heard off camera, emphatically talking over him and each other in disagreement with his assertions. What to say, how to say it, and to whom to say it, particularly in front of a camera, is a source of tension within the family here and in *Watermelons*, when Samih's mother exhorts Guez not to ask him about politics, for fear it will hurt her son professionally.

The schism between self-identification and the way one is identified by outsiders is also addressed in *(Sa)Mira*, an extended monologue by Guez's nineteen year-old cousin, who describes her painful experiences with racism and asserts that she feels "both Israeli and Arab." At a certain point, after breaking down in tears, Samira restarts her narrative from the beginning, and through recounting her story, she analyzes her place within Israeli society with increasing self-awareness. Guez's occasional statements and questions—his voice and person add subtle texture to each video, an intentional blurring of his documentary style—result in Samira's asking, pointedly: "What does it mean to feel Israeli? And what does it mean to feel Arab? Can you enlighten me? I have no idea. What does it mean to feel Jewish?"

Samira's questions are never answered in the video, but they reverberate throughout the exhibition. At various points in all the videos,

each person pauses at length, contemplative, their periods of reti-
cence relaying volumes about the complexity of choosing words, of
voicing their positions. Their religious, ethnic, national, lingual, and
other identity components are all part and parcel of who they are.
Yet the impact of the majority populations—especially the Jewish-
Israeli and Muslim-Palestinian sectors—on their lives and on the
way they describe themselves publicly is palpable. The Monayers'
fluid, shifting, sometimes necessarily contradictory self-definitions,
which embrace numerous identity components, offer a vehement
rejection of monolithic labels. They embody viable alternatives
to the agonistic dichotomies that characterize identity politics
in Israel today—East versus West, Arab versus Jew, Israeli versus
Palestinian, Them versus Us. Taken as a whole, Guez's work under-
mines accepted notions of such polarized divisions and helps us
imagine multiple and unbounded ways of being and belonging.

Emerging from these penetrating conversations with the Monayers,
we journey into an expansive section of the gallery and encounter
two strikingly different vistas: a panoramic, ten-foot light box pho-
tograph, *Two Palestinian Riders, Ben Shemen Forest,* and a single-
shot video of the sun setting on a beach in Jaffa, *SABIR,* both
from 2011. Each site connects to the biographies of Jacob and
Samira Monayer.

Ben Shemen Forest, east of Lod, is one of Israel's largest national
parks. Planted mostly after the foundation of the State of Israel as
part of a major forestation effort, it has become emblematic of the
young nation's transformation of its terrain.[12] Luminous and seduc-
tive, Guez's image verges on cinematic. It drops us into the midst
of the pine trees, where we discern two Palestinians riding horses
bareback, galloping through the forest like ghosts from an ephem-
eral past. The panorama, replete with detail, encourages the kind
of sustained viewing that resembles excavation.

The Palestinian presence hidden within the Israeli landscape
relates to specific personal and collective histories of the forest.
During the 1950s, Jacob Monayer was hired by the Nation's Groves,

a government company that oversaw the planting of Ben Shemen Forest.[13] Working alongside Jewish Israelis, many of them new immigrants, the Christian Arab from Lod supported his family in the aftermath of 1948 by helping to shape a new Israeli landscape. Sections of Ben Shemen Forest are planted over Palestinian villages, which were destroyed and depopulated after the 1948 war.[14] Guez's illuminated, majestic pine forest contrasts sharply with the dark, crumbling, pre-1948 structures of his *Lydd Ruins* series. Together, these landscapes point to the dramatic vicissitudes imprinted in the region. (The towering pines are also a striking contrast to the spindly, fake evergreen Guez decorates in *July 13*.)

In the exhibition, Guez juxtaposes the forest with another, utterly different scene, the open horizon of the Mediterranean Sea. *SABIR* documents a seventeen-minute sunset on a beach in Jaffa and is accompanied by his grandmother's melodic voice. Samira Monayer narrates her childhood years in pre-1948 Jaffa, the town in which she was born in 1932 and where she could walk "100 steps to the Mediterranean" from her family home. Warm memories give way to the watershed events of 1948. She recounts how her family fled coastal Jaffa to inland al-Lydd, seeking refuge from the war; how they hid in the Church of St. George to avoid deportation; how those who were forced into exile never returned; and how she and her family eventually became citizens of the newly established State of Israel. Her autobiographical meditations are fused with the darkening Mediterranean. They also echo the Monayer family videos and inform Guez's images of St. George and the town of Lod.

Throughout her monologue, Samira seamlessly shifts back and forth between her native Arabic and fluent Hebrew. Her bilingual facility relates to the title of the piece, *sabir*—a word derived from the Latin verb "to know"—denoting the lingua franca spoken from the time of the Crusades to the eighteenth century in the ports of the Mediterranean. The Monayers' fluency in Hebrew and Arabic and multiple modes of belonging—as Israeli citizens, Arabs, Christians, and natives of specific locales—dismantle the oppositional structures that govern identity politics in the Middle East.

Unlike Guez's urban or wooded landscapes, or even the interiors of the Monayer family homes, his rendering of the sea is not imprinted with a palimpsest of human intervention over time, with history and nationality. The waves ebb and flow rhythmically; the sun rises and sets cyclically. In this locus, the forces of nature and the voice of individual experience defy the claims of nations and regimes.

Near *SABIR*, Guez displays *Scanograms #1*, a series of scanned family photographs showing Jacob, Samira, and her siblings during the 1940s and '50s. As Guez relates in his essay in this volume, after discovering his grandparents' wedding photographs under their bed in 2009, he established the Christian-Palestinian Archive, comprised of a growing number of photographs and documents. In an act of reparation, the artist salvages, collects, and displays evidence of a dispersed and disregarded community.

· · · ·

Guez's explorations in this exhibition go far beyond the personal as he weaves private memories into the textured fabric of collective histories, geographies, and sites of belonging. As viewers embark on their own epistemological journeys—beyond Israel, beyond 1948, beyond the Monayer family—they are urged to observe the overlooked and to be attentive to the marginalized and the silenced. By unraveling monolithic national identities that impose univocal narratives, Guez's work invites us to experience diverse ways of looking and listening that have the potential to generate alternative, nuanced, and multivalent ways of knowing and being.

Gannit Ankori, professor of art history and theory, chair in Israeli art, Department of Fine Arts and Schusterman Center for Israel Studies, Brandeis University, and Dabney Hailey, director of academic programs, Rose Art Museum, are co-curators of *100 Steps to the Mediterranean*.

NOTES

1 The installation's relationship to church architecture is discussed by Samir Srouji in this volume (see p. 60–65). For information on prior installations of Guez's work, see *Dor Guez: Georgiopolis*, Petach Tikva: Petach Tikva Museum of Art, November 2009–January 2010 (texts by Drorit Gur Arie, Ariella Azoulay, Gil Eyal and the artist) and *Dor Guez: Al-Lydd*, Berlin: KW Institute for Contemporary Art, September 12–November 7, 2010 (texts by Susanne Pfeffer, Felix Ensslin and Ariella Azoulay).

2 See "Lod Conquered by Israel Defense Forces," *Haaretz*, July 12, 1948, 1; Benny Morris, *The Birth of the Palestinian Refugee Problem, 1947–1949* (Tel Aviv: Am Oved, 1991), 272–283 [in Hebrew].

3 One of the most important Palestinian artists, Ismail Shammout (1930–2006), born in al-Lydd, was among those exiled. His monumental painting *Whereto?* (1953) is based on this traumatic experience and has gained iconic status as a representation of the Palestinian Nakba and the refugee experience. On the problems of looting and the role of the Custodian of Absentee Property, see the report by Dov Shafrir, the first to hold the position: "Absentee Property," *Davar*, August 27, 1950, 2, and August 28, 1950, 2 [in Hebrew]. Also see his book *Arugat Hayim* (Tel Aviv: Hoza'at Ha-Merkaz Ha-Haklai, 1975), 220–244 [in Hebrew].

4 The most comprehensive study of the history of the post-1948 city is Haim Yacobi, *The Jewish-Arab City: Spatio-Politics in a Mixed Community* (London: Routledge, 2009).

5 See Haim Yacobi and Erez Tzefadia, "Consolidation of Territorial Identity: Nationalism and Space among Immigrants in Lod," *Theory and Criticism* 24 (Spring 2004): 47 [in Hebrew]. Yoav Gelber writes, "Most of the inhabitants of Lod and Ramla were expelled or left. In Lod about 700 remained, most of them Christians, and in order to attend to their needs a military government was established in the town. Aharon Cohen was appointed as military governor, and was aided by the priests of the congregation." See Yoav Gelber, *Independence versus Nakba* (Or Yehuda: Kinneret, Zmora-Bitan, and Dvir, 2004), 407 [in Hebrew].

6 Anita Shapira, *Yigal Allon, Native Son: A Biography* (Philadelphia: University of Pennsylvania Press, 2008), esp. 226–233. Also see Yitzhak Rabin, "Passage Censored from the First Edition," *The Rabin Memoirs* (Berkeley: University of California Press, 1996), 383–384.

7 Guez's extended family tree includes Arab, Israeli, Christian, Jewish, Palestinian, and Tunisian branches.

8 In 2011 Jacob Monayer passed away and was buried, as he had wished, in Lod Cemetery.

9 See Carol Bardenstein, "Threads of Memory and Discourses of Rootedness: On Trees, Oranges and the Prickly-Pear Cactus in Israel/Palestine," *Edebiyat* 8 (1998): 1–36; and "Trees, Forests, and the Shaping of Palestinian and Israeli Collective Memory," in *Acts of Memory. Cultural Recall in the Present*, ed. Mieke Bal et al., 148–167 (Hanover, NH: University Press of New England, 1999); also see *Watermelons*, Tel-Aviv: The Rubin Museum, November 17, 2009–February 17, 2010 (essay by Shira Naftali).

10 The video's title links two types of cars that are popularly associated in contemporary Israel with Arabs (Subaru) and Israelis (Mercedes), to suggest Sami's composite identity.

11 The term Sami uses, "knowledge of the land" (*Yediat Ha-aretz* in Hebrew), relates to a major aspect of the Israeli ethos. Sami's participation in the Israeli Scouts, the *Gadna* (a paramilitary youth organization), and his extensive hiking trips throughout the "homeland," reflect his sense of belonging to the place and also his paradigmatic Israeli identity.

12 The forestation effort was the work of the Jewish National Fund (JNF), or Keren Kayemet Le-Yisrael, a Zionist organization established in 1901 with the explicit purpose of purchasing land for Jews in Ottoman and, later, British Mandate Palestine. The JNF efforts were designed to carry out the Zionist tenet of "making the desert bloom," and they also provided much-needed jobs in the early years of statehood. The JNF's ideology and forestation projects are well documented on the organization's website, www.jnf.org.

13 The company, which was established in 1952 to manage and cultivate the groves and lands of the Palestinians who became refugees in 1948, was the subject of Guez's one-man show *Nation's Groves*, at the Tel Aviv Museum of Art and the Carlier Gebauer Gallery, Berlin, in 2011. On the Nation's Groves, see Israel State Archives, file gimel-3367/3.

14 Noga Kadman, *Erased from Space and Consciousness: Depopulated Palestinian Villages in the Israeli Zionist Discourse* (Jerusalem: November Books, 2008), 156, table 2 [in Hebrew].

"THIS IS A PHOTOGRAPH OF LOD GHETTO" Dor Guez

PLACE AND DATE Lod, 1949

EVENT Samira and Ya'qoub Monayer's wedding

PHOTOGRAPHER Unknown

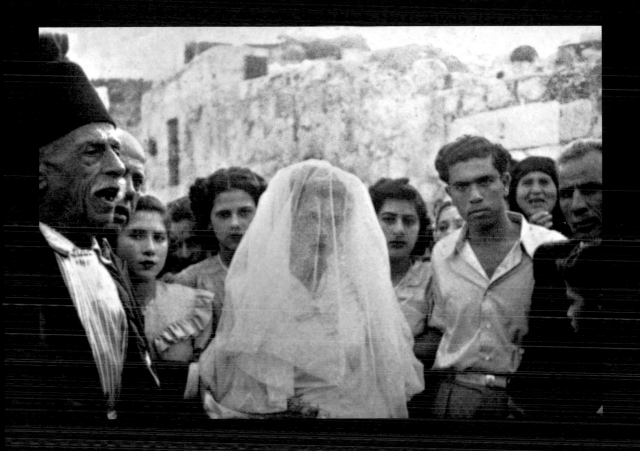

سميرة في فستان عرسها، في أول حفل زفاف مسيحي في اللد بعد ١٩٤٨

Scanograms #1
Image 09
Samira in her wedding
gown, the first Christian
wedding in Lod after 1948

Two events vie for the role of my very first memory. One is my uncle's wedding. I was nearly three years old at the time. His bride's fingers were bedecked with colorful thimbles for the wedding dance. The blurred flickers of color generated by the plastic thimbles moving rhythmically against the white backdrop of her bridal gown are etched in my mind. I have never asked to see my uncle's wedding album, but since weddings are usually documented and reported by both citizen and state, I can probably access the photographic record at will.

The other memory is crisp and more vividly detailed. The actual event probably occurred around the same time, but it was not documented, nor can I date it with precision. I do know with certainty that it took place on a Saturday because that was the day we habitually went to the beach in the summertime. On that particular, undated Saturday morning, my grandmother took my brother and me to the beach in Jaffa, the city where she was born in 1932, and where her childhood home was located 100 steps from the Mediterranean. She no longer lived in Jaffa, but that Saturday morning she carried me into the sea, her back serving as my buoy. The water was calm, without waves. My petite grandmother wore a shiny black swimsuit, and I felt as if I were riding on the back of a whale. Flooded by a sense of security mixed with excitement, I glanced back at Jaffa's shore, the town's sand-colored houses looking tiny on the distant slope.

Several decades later I find myself poring over a photograph of my grandmother's wedding. It was taken by a professional photographer whose name she does not recollect. Her face is shrouded with a translucent chiffon bridal veil, yet one may easily discern her big eyes gazing at the camera. Her painted lips are sealed. Her features resemble those of my mother. She is young and wears a white wedding dress, which separates her from the crowd even as it draws attention to her presence. She is an absent-presence.[1] To her left are her best friend, Nina, and her brother Jack, slimmer and much more handsome than the man I remember from my childhood. She is surrounded by her bridesmaids, dressed in their best, their hair parted

and adorned with ribbons: her cousin Rogette to her right, and the groom's sister, Rowaida, behind her.

It is an occasion that is routinely documented: the bride, accompanied by family and friends, leaves her home and goes out into the public domain, inviting city residents to join the celebration. A Muslim woman, identified by her black scarf, is part of the crowd, attesting to the fact that members of other religions were participants in such festivities. Another short woman on the right stretches her neck up high, hoping to be included in the picture. On the left are two men. Tawfik, Samira's uncle, trying to provide the camera with a full view of his face (alas, half remains hidden); and Issa, the groom's uncle, who appears in profile, wearing a Turkish fez and a striped *galabia* (a traditional Arab garment) with a tailored jacket over it. He doesn't look at the camera. He is on duty, announcing the arrival of the bride, and is captured, mouth wide open, singing in her honor. A certain distance is maintained between the bride and the camera. It is a tacitly observed gap that no one traverses.

I found my grandparents' wedding photographs in 2009 in a white plastic bag inside a frayed suitcase kept under their bed on my grandfather's side. "These are our wedding photos," my grandmother confirmed sixty years after they were taken. "What year was it?" I asked, and she replied, absentmindedly, "a year after 1948," expropriating 1949 from the sequence of time, adjusting to an internal calendar of her own. My grandmother's family was forced to flee Jaffa in 1948, never to return to their home. This much I knew. And so, I let her be and did not ask any more questions.

Later that year, while filming the video *July 13*, I heard my grandfather use the term "Lod Ghetto" for the very first time. I was stunned. In my mind, the term "ghetto" carried different connotations related to urban slums or to Jewish European history.[2] But my grandfather repeatedly said, "Lod Ghetto." I googled "Lod Ghetto" and Google corrected me by asking, "Do you mean Lodz Ghetto?" Later I learned that the name was given by the military government, established by Israel after the 1948 war, to a fenced-in area

around St. George Church in Lod. After the city was conquered by the Israeli army in July 1948, the vast majority of its Palestinian population was forced to march on foot into exile. Only 1,030 people remained in Lod, and they were concentrated in a small area surrounded by barbed wire and placed under military rule and curfews: the Lod Ghetto. The term took root among the city's old-timers as well as the newly arrived Jewish immigrants who settled in Lod after 1948, and even today this area of the city is known as the "ghetto."[3]

In the course of time, photographs blur the images that are etched in our mind, becoming the official visual representatives of those events. Undocumented events are often forgotten, carried into the high seas on one's back. Photography and memory interrelate in diverse ways. Photographs can compete with, obliterate, reinforce, contradict, affirm, or otherwise interact with experienced, undocumented recollections. I have never looked at photographs of my uncle's wedding for fear that the beauty of my memory would not stand the test of time or taste, that the photographs would undermine the personal experience. Nevertheless, it is customary to photograph joyous events, such as weddings, and to arrange the photographs in an album. The presence of a camera raises awareness among participants that the event will be recalled and re-viewed in the future through the resulting images, the most important of which are often framed and displayed in places of honor.

My grandparents' marriage ceremony was the first Palestinian wedding held in Lod after 1948. Inadvertently, their wedding photographs have transcended the role of family mementos and become charged with historical significance as rare archival evidence of life in Lod Ghetto. After my grandmother hired a photographer, posed for him, paid for the photographs, and received them, she shoved them all into a plastic bag, which she buried under the bed. Why didn't she organize the photographs in an album, as was and still is the custom? The historical context provides a key to understanding this dissonance. One doesn't display the pictures of an insult in a family album.

That year I initiated an ongoing project, the Christian-Palestinian
Archive. It began with the photographs in the series *Scanograms
#1*, which refers to the practice of making family albums. The
archive as a whole features images traditionally categorized as
distinct photographic genres: "passport photographs," "wedding
photographs," "class photographs." The documents in the archive
did not originate from actual family albums. They were salvaged
from scattered plastic bags collected in Lod, Amman, London,
Cairo, and Nicosia. Samira Monayer's photograph, shot "a year after
1948," is not from my grandmother's wedding album. Nor is it (just)
a photograph of her marriage. It is evidence of her catastrophe.[4]
Photographs are often described as capturing decisive moments,
but they are also mute. Their silenced meanings emerge in the
space between the image and the viewer. The traumatic historical
context and the archival display restore this photograph's voice as
I write: "This is a photograph of Lod Ghetto."

NOTES

1 "Present-absentee" is the official term used to designate Palestinians who remained in the
 country after 1948, but whose land and property were confiscated and handed over to the
 state. The Absentee Property Law of 1950 grants to the State of Israel the assets of those
 Palestinians deported from it in the 1948 war. Israel's expulsion of Palestinian civilians in
 1948, the confiscation of their property, and the denial of their right to return after the war
 are actions forbidden by the Geneva Convention (IV) relative to the Protection of Civilian
 Persons in Time of War. Geneva, August 12, 1949, articles 49 and 53 (see http://www.icrc.org/
 ihl.nsf/FULL/380?OpenDocument, accessed 6/3/12).
2 The term "ghetto" originated with the Jewish quarter of sixteenth-century Venice, the only
 area of Venice where Jews were allowed to live. Its name was derived from the foundry (geto
 in a Venetian dialect) on the site. "Ghetto" has since become the name used for all Jewish
 quarters throughout Europe. Today the term also denotes a part of a city populated by
 people of a specific ethnic group or of low socioeconomic status.
3 Haim Yacobi, *The Jewish-Arab City: Spatio-Politics in a Mixed Community* (London: Routledge,
 2009), 32, 61.
4 Whereas most of Israel's Jewish citizens refer to the 1948 war as the War of Independence,
 Palestinians refer to the war and its aftermath as the Nakba, or "catastrophe." With the es-
 tablishment of the State of Israel, nearly three-quarters of a million Palestinians were exiled.

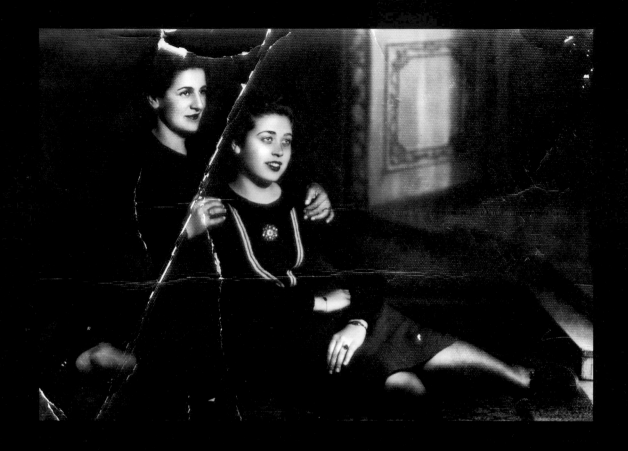

جورجيت منيّر, شقيقة سميرة الكبرى, مع صديقة تمسك بها من الخلف, يافا, ١٩٣٨

In 2009, Guez began assembling the Christian-Palestinian Archive, a collection of photographs, passports, and other documents pertaining to this overlooked and dispersed community from across the Middle East. Selections from the archives, which he calls *Scanograms*, or manipulated ready-mades, are incorporated into his art installations. The series *Scanograms #1* includes images showing Jacob, Samira, and her siblings during the 1940s and 50s.

Scanograms #1
2010
series of manipulated
ready-mades
15 archival ink-jet prints
each 25 ½ × 31 ½ inches

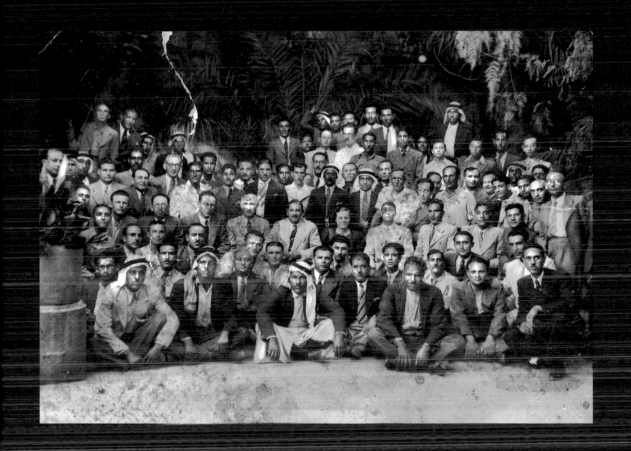

صورة جماعية لموظفي قسم الهندسة في مدينة تل أبيب ومدينة يافا، بمن فيهم يعقوب، يافا ١٩٤٠

Opposite:

Scanograms #1

Image 01

Georgette Monayer, Samira's older sister, with a friend behind holding her, Jaffa, 1938

Above:

Scanograms #1

Image 02

Group photo of the engineering departments for the cities of Tel Aviv and Jaffa, Jacob included, Jaffa, 1940

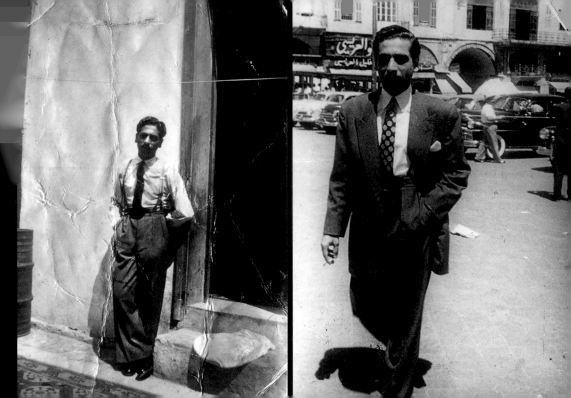

صورة ستوديو ليعقوب، زوج سميرة المستقبلي، تل-ابيب، ١٩٤٢

Scanograms #1
Image 04

Studio photo of Jacob,
Samira's future husband,
Tel Aviv, 1942

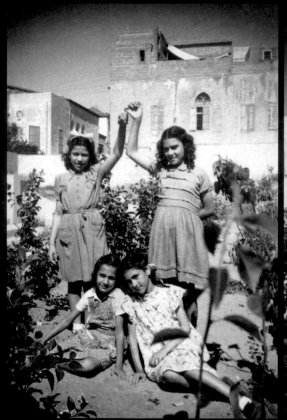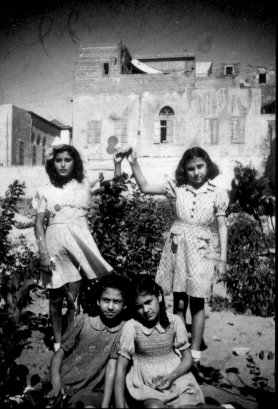

سميرة (من اليسار) مع تلميذات صفها, مدرسة الروم الارثذكس للبنات, يافا, ١٩٤٥

Scanograms #1

Image 05

Samira (on the left) with
her classmates, the
Christian Orthodox Girls
School, Jaffa, 1945

48

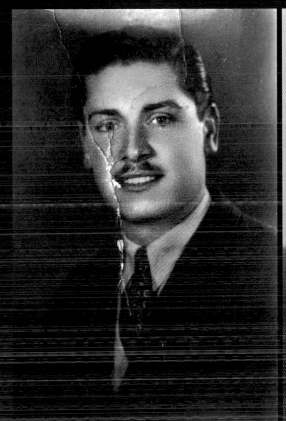
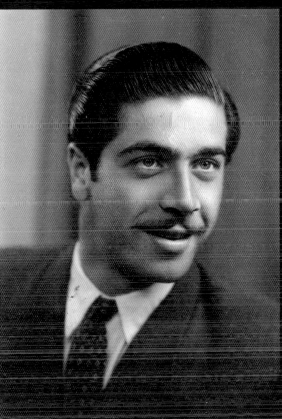

ناصر ومنير, شقيقا سميرة الأكبران, يافا, ١٩٤٧

Scanograms #1
Image 06

Nasser and Moneer,
Samira's older brothers,
Jaffa, 1947

49

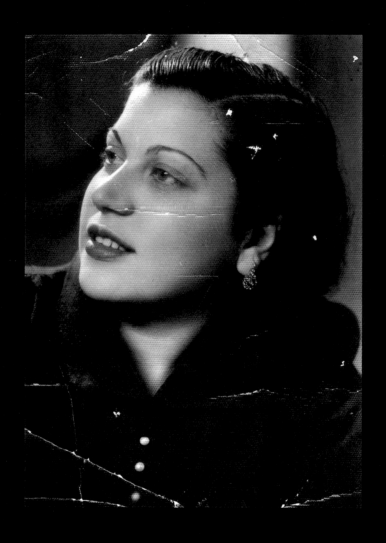

سميرة, يافا, أوائل عام ١٩٤٨

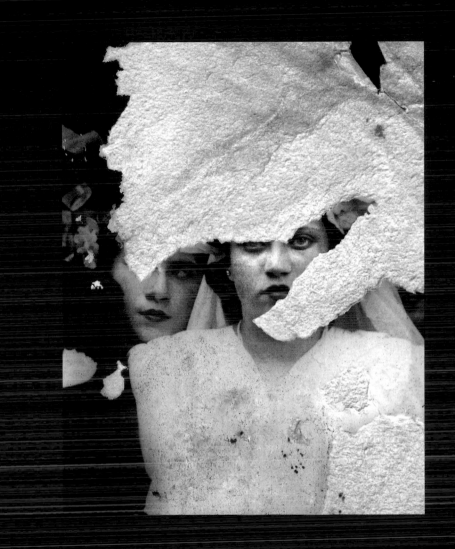

سميرة, غيتو اللد, بعد سنة من ١٩٤٨

Scanograms #1
Image 08

Samira, Lod Ghetto,
a year after 1948

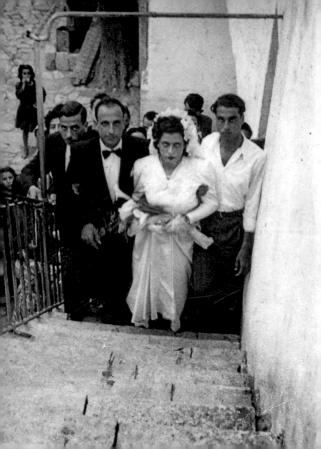

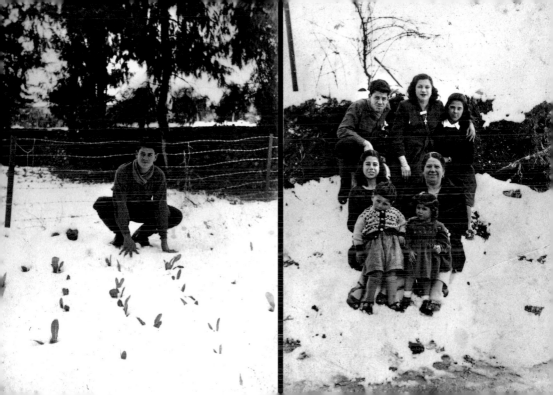

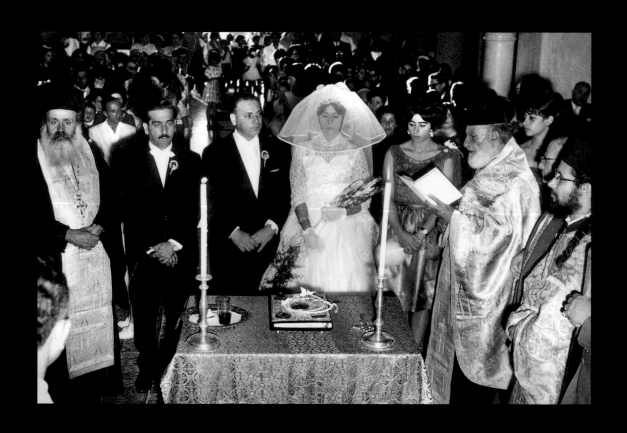

حفل زفاف منير, القاهرة, ١٩٥٤

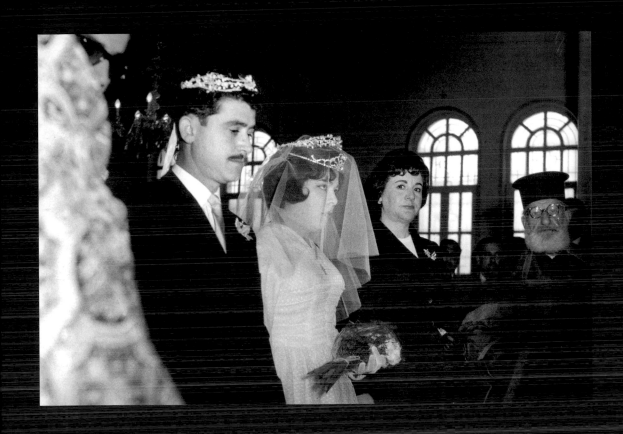

حفل زفاف جاكلين, شقيقة سميرة الصغرى, عمان, ١٩٥٧

Scanograms #1

Image 13

The wedding of Samira's
younger sister, Jaclyn, 1957

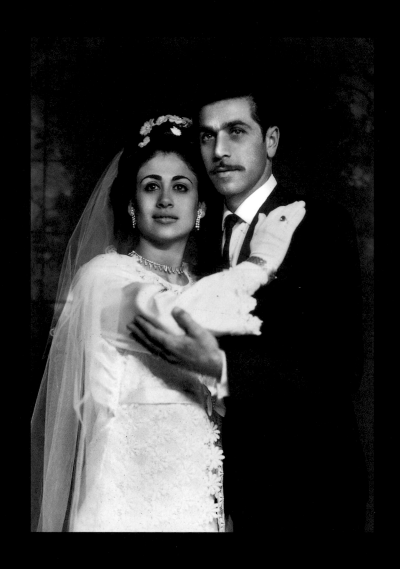

حفل زفاف ناصر, اللد, ١٩٥٧

Scanograms #1
Image 14

Nasser's Wedding,
Lod, 1957

جورجيت مع عائلتها, قبرص, ١٩٥٨

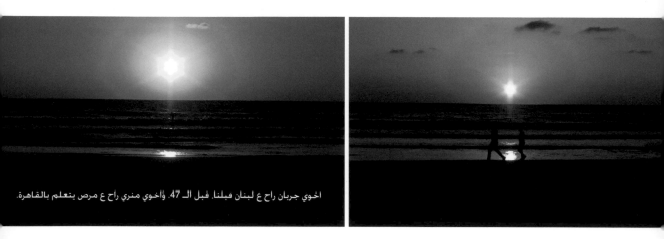

اخوي جربان راح ع لبنان فبلنا. فبل الـ 47. وأخوي منري راح ع مرص ينعلم بالقاهرة.

SABIR
2011
Video
17:30 minutes

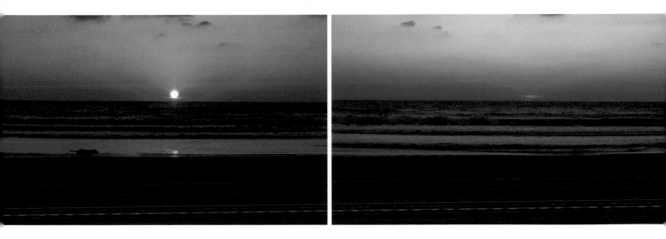

Guez's camera captures the setting sun on a beach in the port city of Jaffa. The lull of waves accompanies Samira Monayer's narration of her childhood years in pre-1948 Jaffa, where she could walk just "100 steps to the Mediterranean" from her family home. As Samira's story unfolds, we hear how her family fled coastal Jaffa to al Lydd, seeking refuge from the 1948 war; how they hid in the Church of St. George; and how they eventually received Israeli citizenship. Throughout her monologue, Samira seamlessly shifts back and forth between her native Arabic and fluent Hebrew. Her bilingual facility relates to the title of the piece, *sabir*—a word derived from the Latin verb "to know"—denoting the lingua franca spoken in Mediterranean ports from the time of the Crusades to the eighteenth century. The sun's slow descent into the sea serves as a visual marker of passing time, fusing her recollections and losses with the disappearing light.

DOR GUEZ'S HOLY OF HOLIES Samir Srouji

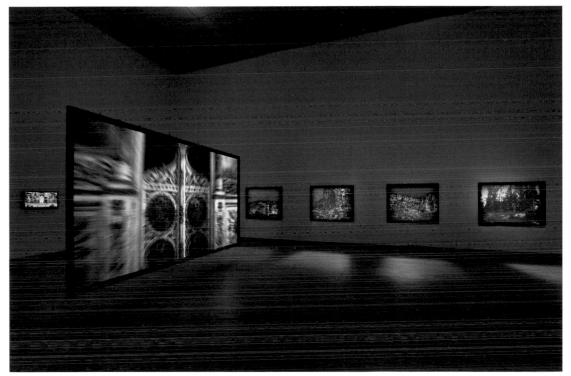

All installation views © Charles Mayer

Above and on pages 66-68:

Installation views of *Dor Guez:*
100 Steps to the Mediterranean
Lois Foster Gallery, Rose Art Museum

Entering *100 Steps to the Mediterranean*, we first encounter Dor Guez's two-channel video installation *Untitled (St. George Church)*, set in a darkened, contemplative space that inspires reverence. On a large floating screen, we see the golden iconostasis at the Greek Orthodox church in al-Lydd.[1] A second, smaller screen shows a priest giving a sermon, while an audio track plays a few strums of an oud—music that is initiated but never completed.

The iconostasis, an architectural feature typical of Eastern Orthodox churches, is a richly decorated wall of icons separating the nave from the sanctuary. The order and placement of icons on the wall follows a strict tradition handed down from Byzantine times, and is highly symbolic. At the wall's center is the Holy Door, which is used only by

priests to access the sanctuary; it is flanked by two smaller doors used by deacons. In the Eastern Orthodox tradition, the sanctuary is a restricted space where priests, deacons, and altar boys are allowed but parishioners are not, and where women are never permitted.

Guez places us directly in front of the principal icons, then slowly pulls the camera back into the nave to reveal the full iconostasis. To move through to the next work and beyond the iconostasis is in effect to accept Guez's invitation into the inner sanctum of the church, and into the metaphorical restricted space of his oeuvre's primary subject, the sanctuary of the personal.

On the second screen the priest, standing at the Holy Door in front of the iconostasis, gives a sermon in Greek (the official language of the Greek Orthodox Church) to his Palestinian parishioners, while a deacon by his side simultaneously translates the sermon into their native Arabic. Guez highlights each act of translation with the haunting notes of the oud, which promises an Arab tune that fails to materialize. By combining the act of translating prayers with the arrested Arab music, which is not permitted in the church, the work underscores the dissonance between church leaders and local parishioners and their respective cultures.[2]

This dissonance is heightened by the visual juxtaposition of *Untitled (St. George Church)* and a series of photographs, *Lydd Ruins* (2009), on the surrounding gallery walls. These nocturnal images, which show remains of the city demolished or fallen to ruin as a result of the 1948 war, are eerily intimate and command a similar sense of reverence.[3] Guez shifts the viewer between the interiority of the sacred space and the exteriority of the city in ruins, and between the private space of contemplation and the public zone of religious and national violence.

Inviting viewers to enter the exhibition through the iconostasis is Guez's first subtle act in subverting the order of things. It is also the beginning of our journey into disjunctive narratives of identity and reflections on the multiplicity of belonging. The exhibition next introduces us to personal stories revolving around the town

of al-Lydd and several generations of the Monayer family: the artist's grandparents, and their children and grandchildren. The arc of Guez's work is an aesthetically sophisticated contemplation on shifting emblems of memory, culture, language, religion, identity, and politics.

The role of the church is central to the lives of Guez's subjects In the video *July 13,* Jacob Monayer (the patriarch of the family) describes how they took refuge in St. George Church during the fighting in 1948, and how it later became part of a fenced ghetto restricting the Palestinians who remained in Lod. The church becomes at once the fortress that stands amid the ruins, a last communal haven for this fading community, and their effective ghetto, defining their otherness despite their attempts at assimilation into Israeli society.[4] Jacob's familial connection to the church runs deep: his grandfather transported stones for the structure, bringing them from Jerusalem on camels, and the adjacent monastery was built on what was originally Monayer land. Later in the video, Jacob is seen trying to enter the church grounds but finding all the gates locked, keeping him out; he subsequently emerges into the nave through an underground passage (from the crypt) and proudly poses for his grandson's camera at the Monayer family chair, reclaiming his position in it.

Guez's transformation of the Foster Gallery in the Rose Art Museum and the precise order and placement of his photographs and videos within its spaces make deliberate references to church architecture. Conceived as an extension of the works themselves, the spaces in which we experience them, and the flow from one to the next, are thoughtfully controlled. Employing the architectural device of compressing and releasing space to maximize psychological effect, Guez narrows the entry to the gallery to create a sense of awe as we are released into the monumental hall, where we encounter the floating iconostasis. The compression is repeated when we exit the *Lydd Ruins* photographs and approach the four video works. The videos, *July 13, Subaru-Mercedes, Watermelons under the Bed,* and *(Sa)Mira,* are arranged in a series of spare enclaves on either side of a central aisle. These spaces are

reminiscent of side chapels in a cathedral. In the videos, we face three generations of the Monayer family, who articulate personal stories of life during and after the Nakba, fractured identities split between assimilation and rejection, and encounters with racism.

In *(Sa)Mira*, Samira, her grandmother's namesake, recounts an episode in which she was asked to choose between her Arabic first name—her grandmother's legacy—and her paycheck. The poignancy of her story lies in the way she gradually peels off layers of cultural identities that she believes simultaneously coexist within her, exposing her scarred and rejected soul in the face of the violence of racism. The exhibition design transforms the site of Samira's self-reflection in this "chapel" into a kind of private confessional; however, in the hands of Guez's subtle subversion, the roles of sinner and absolver are playfully confused.

The themes of dislocation and an equivocal sense of belonging continue in the other testimonial videos, *July 13, Subaru-Mercedes,* and *Watermelons under the Bed*. Sami Monayer in *Subaru-Mercedes* describes his cultural bearing as "essentially Western culture," adding that "in recent years there has been leakage of Eastern culture into my Western culture." His Westernness stems from his assimilation into Israeli culture, which is viewed as superior by many Palestinian Israelis. His use of the term "leakage" tellingly implies that the Eastern culture's "reappearance" in his orientation occurred despite his own efforts. While Sami tries to articulate the conflicts within his identity, his wife and daughters are heard in the background objecting and arguing with his assertions: "Say that you live in Israel but that you do not feel ... Israeli," he is instructed, and "You can't stand up and say that you are a Palestinian. ... You can't feel what they feel." The ambivalence of each person's self-definition does not even encompass other family members' own ambivalence. In these three works, the female voice emerges from the background (always off camera) to editorialize, instruct, and gently direct the male protagonists. In *July 13* the elder Samira, Jacob's wife, interjects, corrects, and adds to her husband's narration of their lives during and after 1948. These female voices are, in keeping with Palestinian tradition, "respectful" of the man's

formal position (in front of the camera) but not afraid to express themselves forcefully and independently. In the "Holy of Holies" that Guez guides us through, women are no longer kept out of the metaphorical inner sanctum but are an articulate and powerful presence in this community.

At the terminus of the central aisle in the exhibit, Guez positions his video work *SABIR*, which features the family matriarch and shows a setting sun and the beach in Yaffa [Jaffa]. Guez's grandmother tells of her memories of life in Yaffa, where she grew up and from which she was forced to flee in 1948. Samira switches from her mother tongue, Arabic, to her later-acquired Hebrew as she emotionally meanders among memories of the past, the Nakba, and the present. Reminiscing about her family's house in the port city, from which it was just "100 steps to the Mediterranean," and evening meals at a café at the water's edge, she longingly describes a world that no longer exists. Her lost paradise is made more fantastic and imaginary by the mesmerizing descent of the sun and the soothing sounds of the Mediterranean. In the analogy to church architecture, *SABIR* takes the position of a rose window above the altar. Samira's nostalgic descriptions of Yaffa and the barbarity of the Nakba correlate to depictions of heavenly places and otherworldly events, carrying Samira's narrative into the realm of the spiritual.

Samir Srouji is an artist and architect at Wilson Architects in Boston.

NOTES

1 The name al-Lydd—the city is also called Lod, Lydda, or Georgiopolis—is used here to reflect the mind-set of the protagonist and not as a strict historical reference.
2 The sounds of the liturgy, moving between Greek and Arabic, take me back to childhood memories of our family's Greek Catholic church in Nazareth, where I was born, and are as natural to my ears as the sound of athaan (the call to prayer for Muslims) followed by church bells, both muffled by the voice of Umm Kulthum, singing through the static on a nearby radio; however, in Guez's installation a layered dissonance is highlighted.
3 For a detailed analysis of the transformation of "the Palestinian city of al-Ludd ... into the 'Hebraic City' of Lod," which is still ongoing, see Haim Yacobi, *The Jewish-Arab City: Spacio-Politics in a Mixed Community* (London: Routledge, 2009).
4 The Christian Arabs make up approximately 10 percent of the total Palestinian population of Israel. According to the Lod municipality, the population of the city is 74,000; 72.5 percent are Jews and 27.5 percent are Arabs, mostly Muslims. Only 1,000 are Christians.

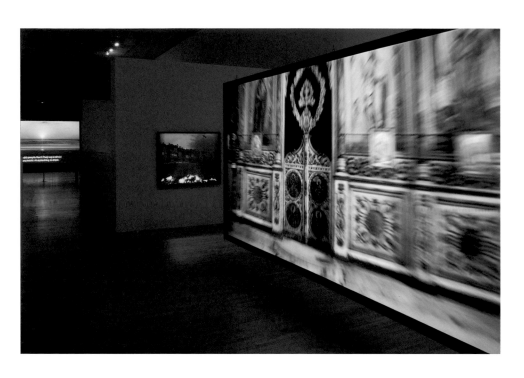

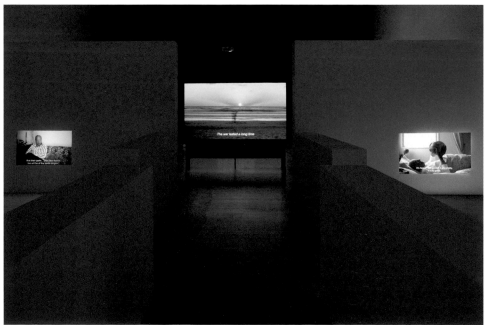

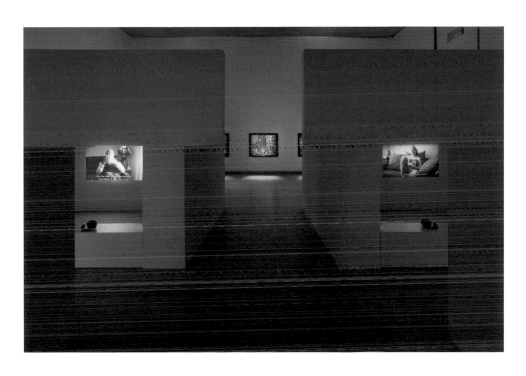

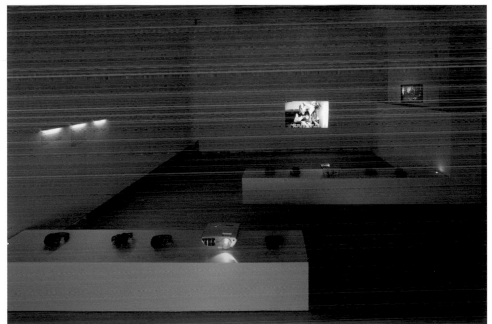

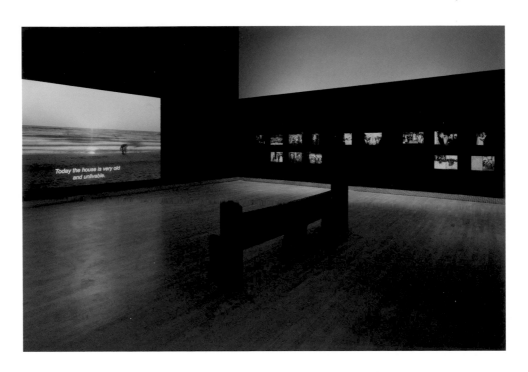

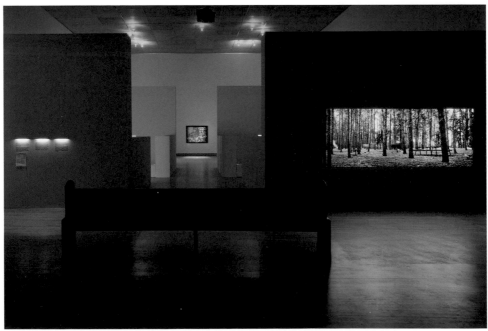

**Two Palestinian Riders,
Ben Shemen Forest**
2011
Color transparency
in light box
49 ³/₄ × 118 ³/₈ inches

Pine forests abound in Israel and are usually perceived to be part of the country's "natural" landscape. In fact, the Jewish National Fund planted millions of pine trees across thousands of acres, dramatically modifying the terrain, especially after the foundation of the State of Israel in 1948. Guez's panoramic view of Ben Shemen Forest, one of the largest national parks in the country, includes two barely discernable Palestinians on horseback.

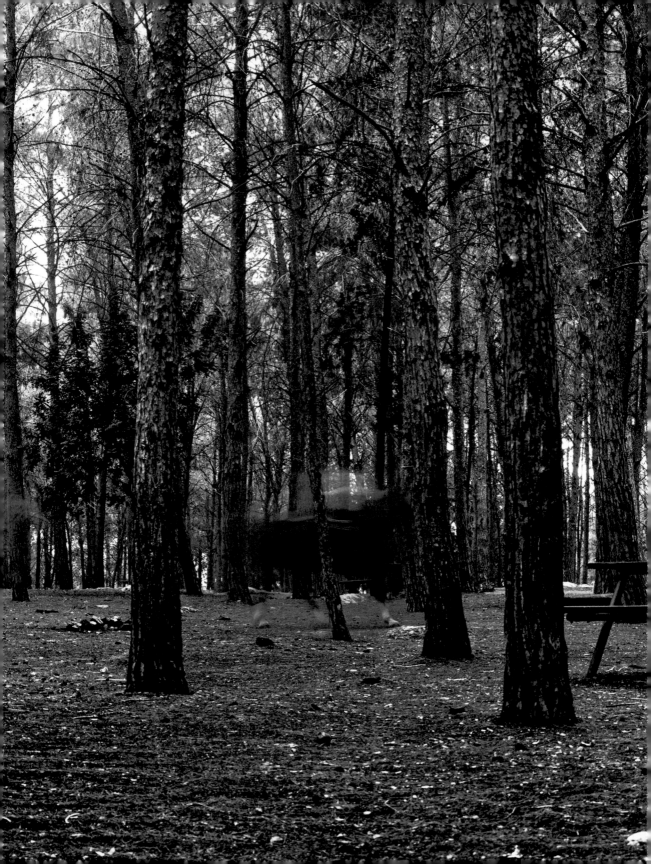

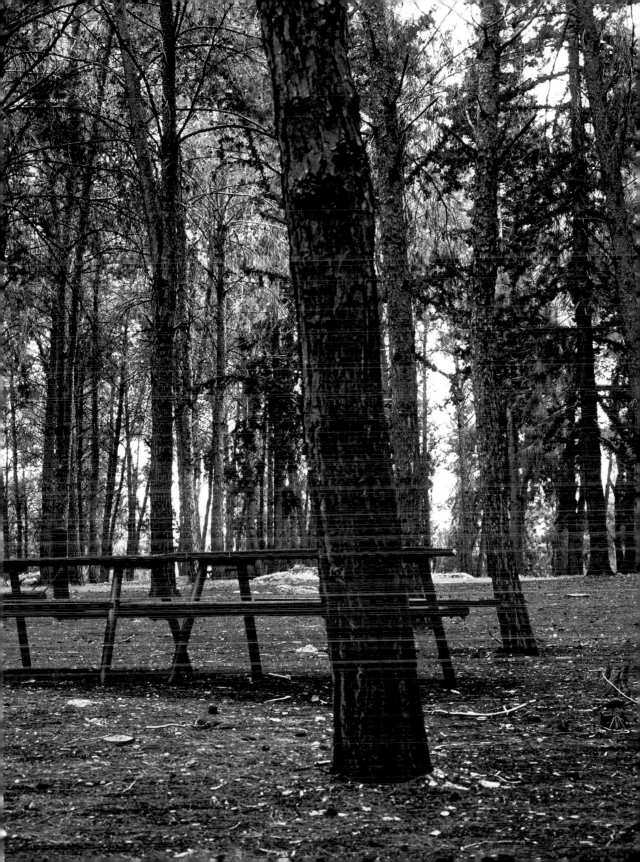

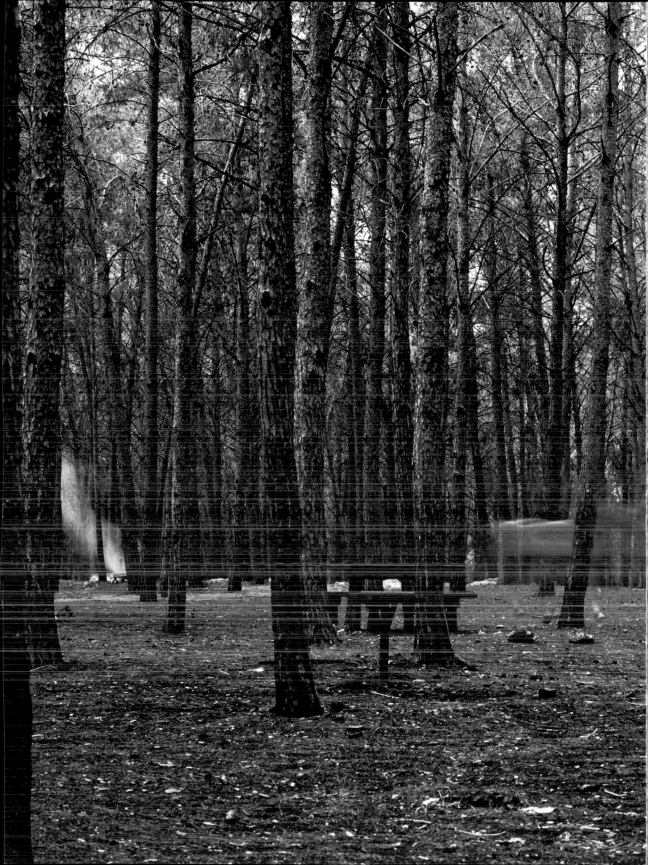

WORKS IN THE EXHIBITION

Lydd Ruins 1-8, 10
2009
9 chromogenic prints
Each 47 ¼ x 59 inches

Untitled (St. George Church)
2009
Two-channel video installation
8.59 minutes

July 13
2009
Video
13:18 minutes

Watermelons under the Bed
2010
Video
8:00 minutes

Subaru-Mercedes
2009
Video
6:00 minutes

(Sa)Mira
2009
Video
13:40 minutes

SABIR
2011
Video
17:30 minutes

Scanograms #1
2010
A series of manipulated readymades
14 archival inkjet prints
Each 25 ½ x 31 ½ inches

Two Palestinian Riders,
Ben Shemen Forest
2011
Color transparency in light box
49 ¼ x 118 ⅛ inches